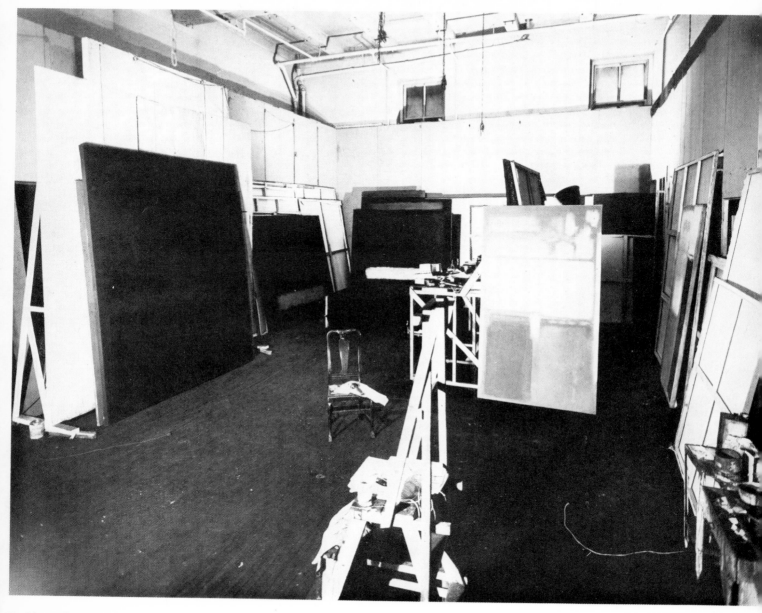

Rothko studio, 1960. Photo Herbert Matter

MARK ROTHKO

PETER SELZ *The Museum of Modern Art, New York*

Reprint Edition 1972

Published for The Museum of Modern Art by Arno Press

DEPARTMENT OF PAINTING
AND SCULPTURE EXHIBITIONS

James Thrall Soby, *Chairman*

Peter Selz, *Curator*
William C. Seitz, *Associate Curator*
Alicia Legg, *Assistant Curator*
Frank O'Hara, *Assistant Curator*
Karen Bokert, *Secretary*
Sally Kuhn, *Secretary*

Published by the Museum of Modern Art, New York, 1961
All rights reserved

Designed by Susan Draper

Library of Congress Catalog Card Number 76-169316
ISBN 0-405-01574-7
Printed in the United States of America

CONTENTS

Acknowledgments 6

Lenders to the Exhibition 6

Biography of the Artist 7

Mark Rothko 9

Bibliography 40

List of Exhibitions and Reviews 41

Catalogue of the Exhibition 43

ACKNOWLEDGMENTS

On behalf of the Trustees of the Museum of Modern Art I wish to thank Mark Rothko for his close cooperation in the preparation of both the exhibition and the catalogue, and for the many paintings he himself is lending. I also wish to express my appreciation to the collectors and museums whose names appear below; their generosity has made this exhibition possible. For special assistance I am grateful to Governor Nelson A. Rockefeller, Dr. and Mrs. Frank Stanton and Mr. and Mrs. Burton G. Tremaine.

I want especially to acknowledge my indebtedness to Wilder Green for his invaluable suggestions on the installation of the exhibition.

PETER SELZ, *Director of the Exhibition*

LENDERS TO THE EXHIBITION

Dr. and Mrs. Edgar F. Berman, Baltimore; Mr. and Mrs. Donald Blinken, New York; John Ciampi, New York; Lady D'Avigdor Goldsmid, London; Mr. and Mrs. I. Donald Grossman, New York; Mr. and Mrs. Ben Heller, New York; Mrs. Josephine Kantor, Pacific Palisades, California; Dr. Giuseppe Panza di Biumo, Milan; Mr. and Mrs. Bernard J. Reis, New York; Miss Jeanne Reynal, New York; Governor Nelson A. Rockefeller, New York; Mark Rothko, New York; Mr. and Mrs. William Rubin, New York; Theodoros Stamos, New York; Dr. and Mrs. Frank Stanton, New York; Mr. and Mrs. Burton G. Tremaine, Meriden, Connecticut.

Albright Art Gallery, Buffalo, New York; The Art Institute of Chicago; The Museum of Modern Art, New York; Whitney Museum of American Art, New York; Vassar College, Poughkeepsie, New York; Phillips Collection, Washington, D.C.

Sidney Janis Gallery, New York.

BIOGRAPHY OF THE ARTIST

Mark Rothko was born in Dvinsk, Russia on September 25, 1903. In 1913 his family left Russia to settle in Portland, Oregon, where he attended public school and high school. He entered Yale University in 1921 and studied the liberal arts, but left in 1923 because he was not sufficiently interested in academic training. By 1925 Rothko had settled in New York and begun tentatively to draw from the model. For a brief time he painted in Max Weber's class at the Art Students League. Thereafter he painted by himself.

Rothko exhibited for the first time in 1929 when Bernard Karfiol selected several paintings for an exhibition at the Opportunity Gallery. In the early 1930s his work was included in group shows at the Secession Gallery. The Contemporary Arts Gallery gave him his first one-man show in New York in 1933. In 1935 he was a co-founder of "The Ten," a group with expressionistic tendencies that held annual shows for almost a decade, principally at the Montross and Passedoit galleries. Rothko worked on the W. P. A. Federal Arts Project in New York in 1936–37. In 1940 J. B. Neumann showed a number of his paintings at the Neumann-Willard Gallery. In 1945 Peggy Guggenheim showed a series of paintings with strong affinities with surrealism in an important one-man exhibition at her New York gallery, Art of This Century. He also exhibited with the Federation of Modern Painters and Sculptors for a number of years and he was represented in annual exhibitions at the Whitney Museum of American Art from 1945 to 1950. He joined the Betty Parsons Gallery in 1946 and his first show was an exhibition of watercolors. Thereafter he showed there annually until 1951. In 1947 his style had formulated into the characteristic rectangular shapes floating in space, by which he is known. In 1954 he joined the Sidney Janis Gallery and has since exhibited there regularly. The Museum of Modern Art, New York included him in the exhibitions *15 Americans* in 1952 and *The New American Painting*, which was shown in eight European countries in 1958–59. Together with Mark Tobey, David Smith and Seymour Lipton, Rothko was shown in the U. S. Representation, XXIX Biennale, Venice, in 1958. A selected list of exhibitions in the U. S. and abroad appears on page 41.

Rothko has also had a teaching career: From 1929–1952 he taught children at the Center Academy, Brooklyn, New York; during the summers of 1947 and 1949 at the California School of Fine Arts, San Francisco; in 1948 co-founder and teacher at a school on East 8th Street, New York, "Subjects of the Artists"; from 1951–54 on the staff of the Art Department, Brooklyn College; 1955, visiting artist, University of Colorado, Boulder, Colorado; winter, 1956, visiting artist, Tulane University, New Orleans, Louisiana.

In 1950 Rothko went to Europe, traveling in England, France and Italy, and in 1959 he revisited these countries as well as Holland and Belgium.

In 1958 he began a series of murals for a large private dining room on Park Avenue, New York. After eight months of work, when the paintings were completed, the artist decided they were not appropriate for the setting and therefore did not deliver the work. Some of these panels are being shown in this exhibition.

Rothko's work is represented in the following public collections: The Baltimore Museum of Art; Albright Art Gallery, Buffalo; The Art Institute of Chicago; The Brooklyn Museum, New York; The Museum of Modern Art, New York; Whitney Museum of American Art, New York; Museu de Arte Moderna, Rio de Janeiro; San Francisco Museum of Art; University of Arizona, Tuscon; Munson-Williams-Proctor Institute, Utica; Peggy Guggenheim Collection, Venice; Phillips Collection, Washington, D. C.

A. L.

The intimate view of Vermeer and Vuillard is denied to current experience; it no longer fits into our scale of values. The sunlit, peacefully disciplined interior of Vermeer seems to offer the outsider a candid glimpse into a well-regulated life which, though he may not enter it, yet presents him with a vision of order to contemplate. But desirable as this quiet world appears, it is no longer accessible to the modern artist, who requires different visions. The painters of the New York School have set out to create their own environments. Intolerant of the chaotic mass culture in which they live, they have also become thoroughly disillusioned with the painting of social and political revolt. (How far away the thirties seem to be!) And yet they reject the expressionist attitude of personal antagonism vis-a-vis society. Even the American scene does not to any extent inspire their mural-sized paintings. The vast plateaus of the Northwest, the vaster bottom-lands of Texas constitute only a small part of the artistic experience of these painters, whose culture is based chiefly on European art. Their large paintings have been formed within the walls of dreary lofts and studios, in the very heart of a congested city.

In his New York studio Mark Rothko has built a new habitat of extraordinary emotional dimensions. His paintings can be likened to annunciations. Rothko returned from a trip to Italy with great admiration for Fra Angelico's frescoes in the monastery of Saint Mark's. But no angels and madonnas, no gods, no devils furnish a common property to be invoked in Rothko's paintings. There is no public myth to express the modern artist's message for him. The painting itself is the proclamation; it is an autonomous object and its very size announces its eminence.

That the sense of belonging is gone and cannot be recaptured under the circumstances in which we live, is a truism. The personal estrangement of the artist from the mass culture surrounding him had better be accepted. But Rothko indeed has welcomed this new-found freedom; he wrote in the mid-forties: "The unfriendliness of society to his activity is difficult for the artist to accept. Yet this very hostility can act as a lever for true liberation. Freed from a false sense of security and community, the artist can abandon his plastic bankbook, just as he has abandoned other forms of security. Both the sense of community and of security depend on the familiar. Free of them, transcendental experiences become possible."[1]

Rothko paints large surfaces which prompt us to contemplate. The actuality of the painted surfaces makes even the symbolic configurations of his earlier work unnecessary. His rectangular configurations have been compared with the work of the followers of neo-plasticism, but unlike them, Rothko does not paint about optical phenomena or space and color relationships. His work has also at times been classed erroneously with action painting, yet he does not inform us about the violence and passion of his gesture.

Holding tenaciously to humanist values, he paints pictures which are in fact related to man's scale and his measure. But whereas in Renaissance painting man was the measure of space, in Rothko's painting space, i.e. the picture, is the measure of man.

This is perhaps the essential nature of the viewer's

response to Rothko's work: he contemplates these large surfaces, but his vision is not obstructed by the *means* of painting; he does not get involved in the by-ways of an intriguing surface; these pictures do not remind us of peeling walls or torn canvases. The artist has abandoned the illusions of three-dimensional recession; there is not even the space between various overlaid brush-strokes. The surface texture is as neutral as possible. Seen close up and in a penumbra, as these paintings are meant to be seen, they absorb, they envelop the viewer. We no longer look *at* a painting as we did in the nineteenth century; we are meant to enter it, to sink into its atmosphere of mist and light or to draw it around us like a coat—or a skin.

But, to repeat, they also measure the spectator, gauge him. These silent paintings with their enormous, beautiful, opaque surfaces are mirrors, reflecting what the viewer brings with him. In this sense, they can even be said to deal directly with human emotions, desires, relationships, for they are mirrors of our fantasy and serve as echoes of our experience.

It is important for an understanding of the art of this painter, whose work seems to have little precedent in the history of painting, that the visual arts formed no part of his early background. He recounts that art simply did not exist around him in his youth, that he was not aware of museums or art galleries until he was in his twenties. Since childhood, however, he had been preoccupied with cultural and social values. When Rothko finally encountered the world of painting, his mind was fully formed—much as Kandinsky's had been at the time of his arrival in Munich some thirty years earlier, before he became the great pioneer of early twentieth-century painting.

Rothko's task now was to make of painting something as powerful and as poignant as poetry and music had seemed to him, to make his painting an instrument of similar force. Even today, he says, he is concerned with his art not esthetically, but as a humanist and a moralist.

Rothko is largely self-taught as a painter. In fact, his paintings show no direct reflection of the painting of the past. His work has been highly individualistic from the beginning. His city scenes of the thirties are characterized by large flat shapes of subtle color, for the plane of the picture asserts itself early in his work. Immobile human figures, isolated and without contact with each other were the subject matter. "But the solitary figure could not raise its limbs in a single gesture that might indicate its concern with the fact of mortality and an insatiable appetite for ubiquitous experience in face of this fact."[2]

Rothko has never abandoned his search for means of expressing human emotion, although he no longer employs the symbol of the figure to enact his drama. He has found his own more conclusive way of dealing with human qualities and concerns.

Toward the eventual achievement of this vision, the experience of surrealism proved a liberating instrument for Rothko as it did for so many other American artists of his generation. He has always admired Dali, de Chirico, Miró, and Max Ernst. The impact of surrealism led to an exploration of myth. But his archaic mythological beings of the early forties, his soothsayers and oracles, are generalized and not recognizable. They appear to inhabit an imaginary world below the sea, and the familiar identity of things is destroyed by these organic, biomorphic beings made up of elements partly human, animal, or vegetable. These symbolic abstractions are muted in color and always dominated by a swirling calligraphic line. He exhibited this biomorphic series in his first important one-man show, held at Peggy Guggenheim's Art of This Century in 1945.

Soon thereafter the flat plane reasserted itself, and by 1947 Rothko was using diffuse, rectangular color shapes, permitting them to float freely in his ambiguous space. It was difficult for an unprepared audience to comprehend this departure into a new, completely uncharted world. "Yet the remarkable thing about that period was that the artist was really not alone, that there always was a small audience which greeted each new manifestation as an answer to what had to be done."[3] Nevertheless, on the occasion of a decisive show, held at the Betty Parsons Gallery, M. B. wrote in the *Art Digest* of April 1949: "But the unfortunate aspect of the whole showing is that these paintings contain no suggestions of form or design. The famous 'pot of paint flung at the canvas' would apply here with a nicety."[4]

Despite a complete lack of understanding of Rothko's indifference to accepted principles of design—of achieving precision without resorting to formulae—the reviewer's reference to Ruskin's celebrated insult is actually valid. Thomas B. Hess in fact immediately recognized an orientalism similar to Whistler's.[5] The orientalism may be doubtful, but as in Whistler's "Nocturnes," the shapes in Rothko's paintings are enveloped in mist. Less static, however, these thinly painted, elusive rectangles move past each other without friction, slowly, in veiled silence.

In 1943, in a letter written jointly by Rothko and Gottlieb to the *New York Times,* the artists outlined some of their esthetic beliefs. One of them: "We favor the simple expression of the complex thought."[6] Rothko achieved a further simplification around 1950. Subject matter in the conventional sense had, as we know, been abandoned for some time. Now line and movement were also eliminated.

Although the thin application of paint always permits an awareness of the weave of the canvas, texture is not important. Conventional recession into depth, as well as weight and gravity, has been eliminated, yet we cannot even speak of flatness when confronted with the surfaces which actually breathe and expand. Light has become an attribute of color. Few of the elements which are a part of most paintings have remained. In fact, Rothko's constant stripping-down of his pictures to their barest essentials, to a simplicity beyond complexity, is intrinsic to their being. His paintings disturb and satisfy partly by the magnitude of his renunciation.

Color, although not a final aim in itself, is his primary carrier, serving as the vessel which holds the content. The color may be savage, at times burning intensely like sidereal landscapes, at others giving off an enduring after-glow. There are paintings whose reds are oppressive, evoking a mood of foreboding and death; there are reds suggesting light, flame, or blood. There are pictures with veil-like blues and whites, and blues suggesting empty chambers and endless halls. At times the color has been gayer, with greens and yellows reminiscent of spring in its buoyant, almost exultant delight. There is almost no limit to the range and breadth of feeling he permits his color to express.

If color sets the general tenor of the mood, the shape gives a more specific feature as well as a more concrete character. Similar as the shapes may appear, the rectangular color fields vary considerably from painting to painting. They are always presented in relentless frontality in the canvases of the fifties. These symmetric shapes are usually not sharply outlined; they are never frozen, and are able to shift along a lateral axis because of their blurred edging. Areas often seem to fade into each other, or they may be most emphatically separate; the relationships between Rothko's shapes in space, however, are never explicitly defined. They are only implied, whispered, or, one might say, revealed. Between the major fields there are often zones which

simultaneously divide and unify. "It is at the divide between the rectangular expanses of color forms that suspense—that element which Rothko calls violence—invigorates almost imperceptibly the overall lyricism."[7]

Although recession into depth has been eliminated, Rothko's canvases are by no means flat, two-dimensional areas of color and pattern. To be sure, there is no depth illusion as in Renaissance painting, nor is there the constructed space of cubism or the planar quality of Mondrian. The "space" is not really *in* these pictures of Rothko's, but rather it inheres in the sensations of actual physical imminence, of immediate impingement, which they evoke in the viewer. And since man can be cognizant of existence, can *feel,* that is to say, only in a continuum of space, the space sensations in these pictures actually occur outside of the picture plane, on some meeting ground between the picture and the viewer.

A great many of Rothko's paintings of the fifties make us feel as if a charge has been set up; we seem to be confronted with the world during the heavy hours preceding the storm, when the clouds are about to close in on each other. Yet whereas the color shapes are informed with some impending ominous transformation the canvases are, so to speak, suspended at the point of instability. The spectator contemplates an atmosphere of alarm in which the contact of electrically charged and dangerous elements is held in check by the tense areas between them. In some pictures the vibrating areas are pulled apart by the outside color frames.

In other paintings we feel that all movement has eased. These suggest the aftermath of once violent activity. Eventually as other images occur to the viewer the metaphor of the creation of some universe becomes paramount. And increasingly—in the mind of this writer—these "shivering bars of light" assume a function similar to that loaded area between God's and Adam's fingers on the Sistine ceiling. But Rothko's creation can no longer be depicted in terms of human allegory. His separated color areas also create a spark, but now it takes place in some sort of revolving atmospheric universe rather than between Michelangelo's man and his God. Rothko has given us the first, not the sixth, day of creation.

An Apollonian intensity becomes evident in Rothko's work once we go beyond the immediate sensual appeal of the beautiful color relationships. In her interpretations of Rothko's work, Dore Ashton has compared it with Greek drama, "to the fatalism, the stately cadence and the desperately controlled shrieks."[8] Indeed, his work does not so much resolve agitation as contain it, in the sense of holding it within bounds. These apparently quiet, contemplative surfaces are only masks for underlying turmoil and passion.

In recent years even the bright or blazing colors have been largely subdued to make way for painting of a somber ritualistic nature. "As I have grown older, Shakespeare has come closer to me than Aeschylus, who meant so much to me in my youth. Shakespeare's tragic concept embodies for me the full range of life from which the artist draws all his tragic materials, including irony; irony becomes a weapon against fate."[9]

In 1958, when he began to paint murals commissioned for a large private dining room, they turned out to be paintings which may be interpreted as celebrating the death of a civilization. In these vast canvases he abandoned solid color areas for rectangular frames of a single hue set in a field of solid color.

The open rectangles suggest the rims of flame in containing fires, or the entrances to tombs, like the doors to the dwellings of the dead in Egyptian pyramids, behind which the sculptors kept the kings "alive" for eternity in the *ka.* But unlike the doors of the dead,

No. 8, 1952. Oil on canvas, 6′ 8½″ × 68″. Collection Mr. and Mrs. Burton G. Tremaine, Meriden, Conn.

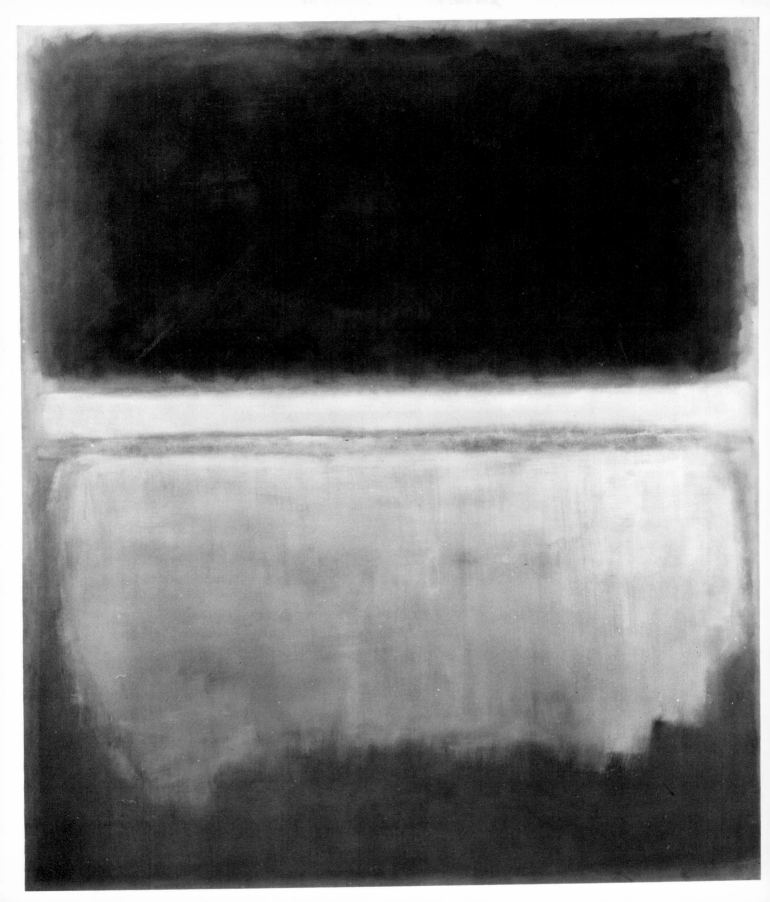

which were meant to shut out the living from the place of absolute might, even of patrician death, these paintings—open sarcophagi—moodily dare, and thus invite the spectator to enter their orifices. Indeed, the whole series of these murals brings to mind an Orphic cycle; their subject might be death and resurrection in classical, not Christian, mythology: the artist descending to Hades to find the Eurydice of his vision. The door to the tomb opens for the artist in search of his muse.

For about eight months, Rothko was completely occupied in the execution of his mural commission. When it was finished, and the artist had actually created three different series, it was clear to him that these paintings and the setting did not suit each other. One may go so far as to say that this modern Dance of Death had developed into an ironic commentary on the elegant Park Avenue dining room for which it had originally been intended. Like much of Rothko's work, these murals really seem to ask for a special place apart, a kind of sanctuary, where they may perform what is essentially a sacramental function. This is not an absurd notion when one considers the profoundly religious quality of much apparently secular modern art—indeed, the work of art has for a small but significant number of people (including spectators as well as artists) taken on something of the ecstatic and redeeming characteristics of the religious experience. Perhaps, like medieval altarpieces, these murals can properly be seen only in an ambiance created in total keeping with their mood.

Rothko's most recent dark paintings, done after the "Orphic cycle," combine the palette of these murals with the figuration of the previous period. They have the glowing color of embers and are as relentless in their austerity. Nietzsche wrote in *The Birth of Tragedy*

an essay Rothko had read with great admiration when he was a young man: "There is need for a whole world of torment in order for the individual to produce the redemptive vision and to sit quietly in his rocking rowboat in mid-sea, absorbed in contemplation."[10]

P. S.

NOTES TO THE TEXT

[1] Mark Rothko, *Possibilities I,* Winter 1947/48 "The Romantics Were Prompted," p. 84

[2] *Ibid.*

[3] Mark Rothko, interview with the author, autumn 1960

[4] M. B., *Art Digest,* April 15, 1949, Vol. 23, No. 14 Fifty-Seventh Street in Review, "Mark Rothko at Parsons," p. 27

[5] T. B. H., *Art News,* April 1949, Vol. XLVIII, No. 2 Reviews and Previews, "Mark Rothko (Parsons; to April 16)," p. 49

[6] Letter, *New York Times.* June 13, 1943. Jointly with Adolph Gottlieb

[7] Georgine Oeri, *The Baltimore Museum of Art News,* Vol. XXIII, No. 2, Winter 1960 "Rothko's 'Olive over Red'," p. 8

[8] Dore Ashton, *Arts and Architecture,* August 1957 "Mark Rothko," p. 8

[9] Mark Rothko, interview with the author, autumn 1960

[10] Friedrich Nietzsche, *The Birth of Tragedy,* translation by Francis Golffing, New York, Doubleday & Company, 1956, pp. 33–34

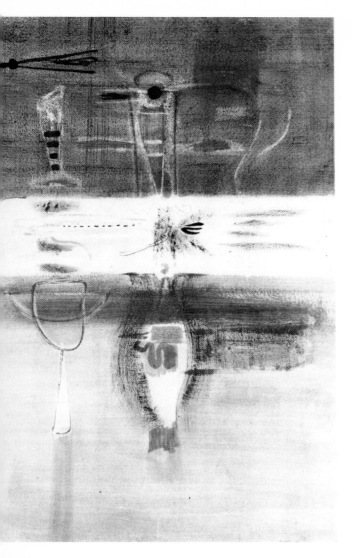

Untitled. 1946. Watercolor, 38³/₄ × 25¹/₂″. Collection Mr. and Mrs. Donald Blinken, New York

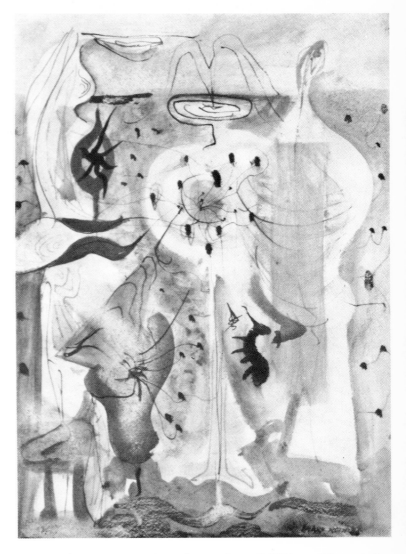

Baptismal Scene. 1945. Watercolor, 19⁷/₈ × 14″. Whitney Museum of American Art, New York

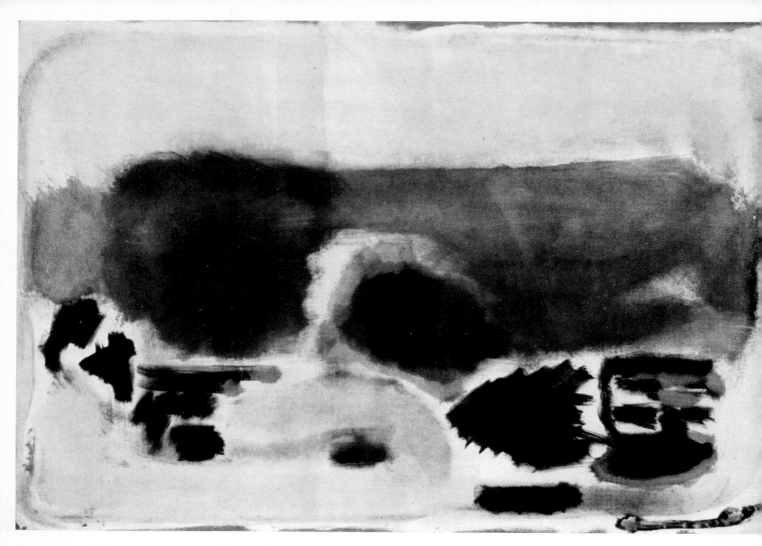

No. 24, 1947. Oil on canvas, 33¹/₂ × 50″. Owned by the artist

No. 18, 1948. Oil on canvas, 67¹/₄ × 56″. Vassar College, Poughkeepsie, New Yo

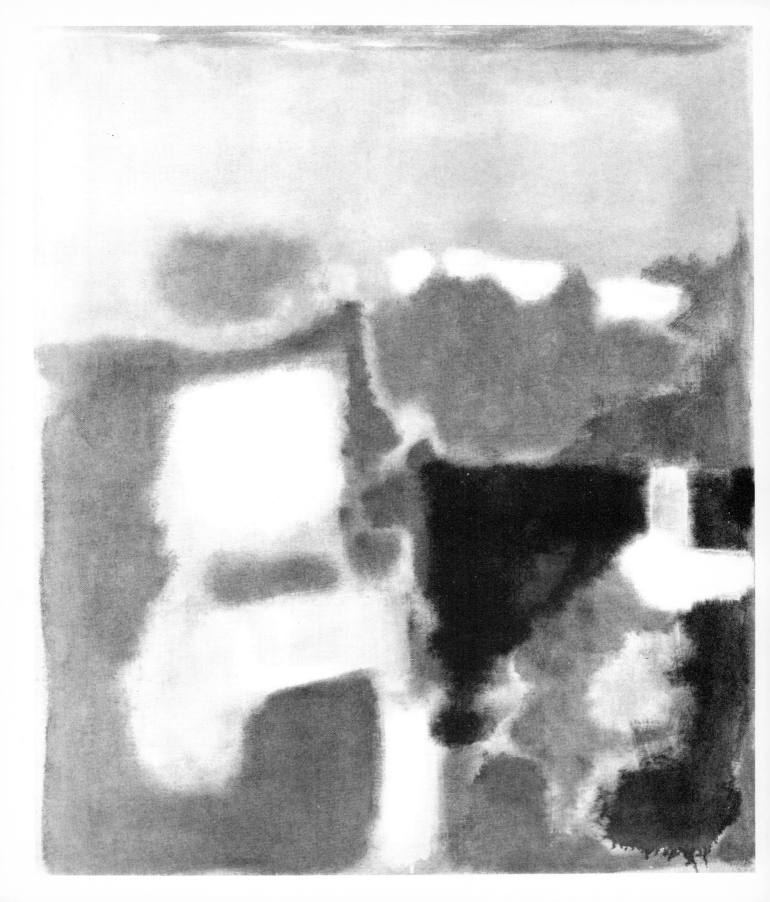

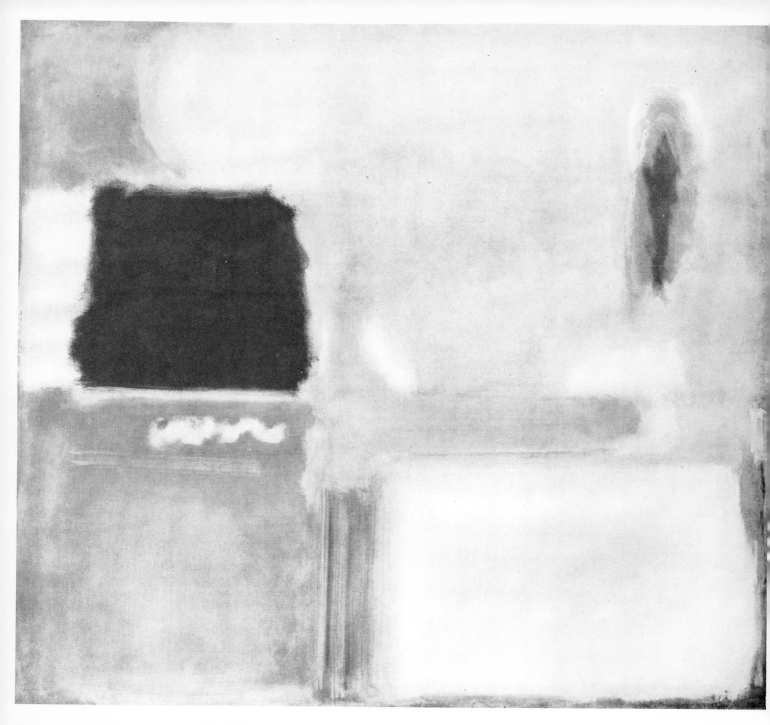

No. 12, 1948. Oil on canvas, *58 × 64″.* Phillips Collection, Washington, D. C.

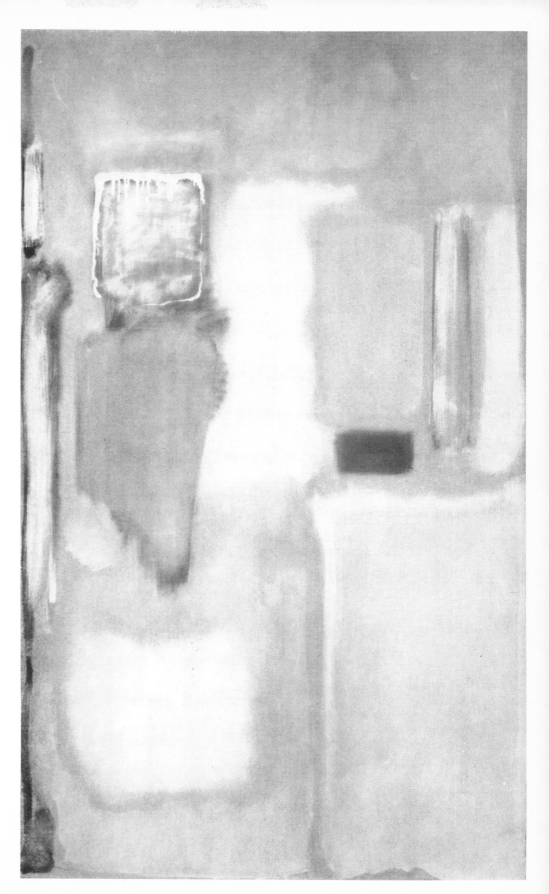

19, 1948. Oil on canvas, 68 × 40″.
Art Institute of Chicago, anonymous gift

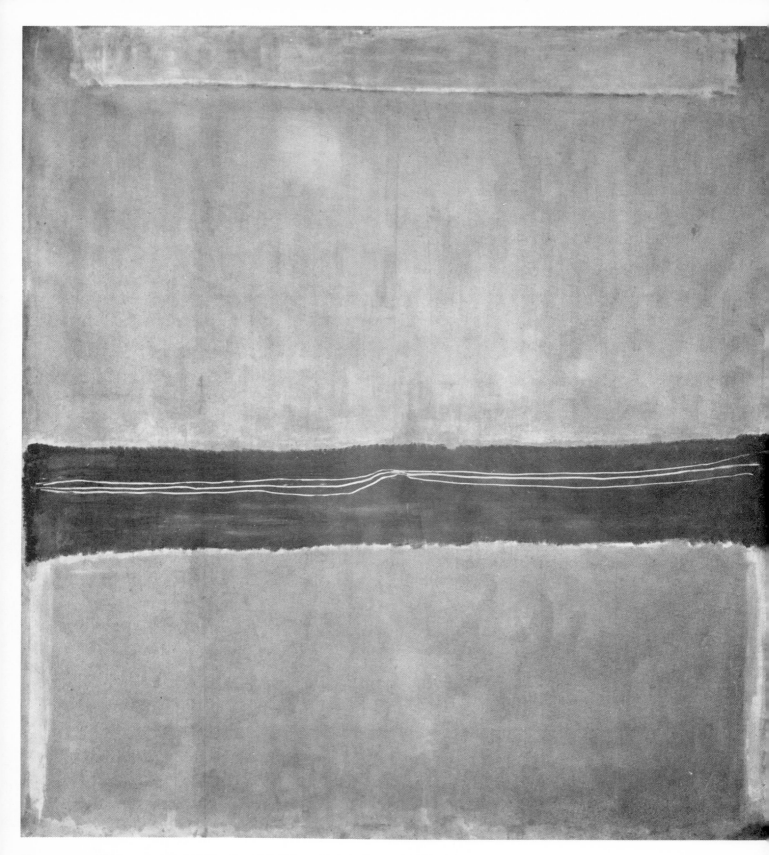

No. 22, 1950. Oil on canvas, 9′ 9¹/₂″ × 8′ 10³/₄″. Sidney Janis Gallery, New York

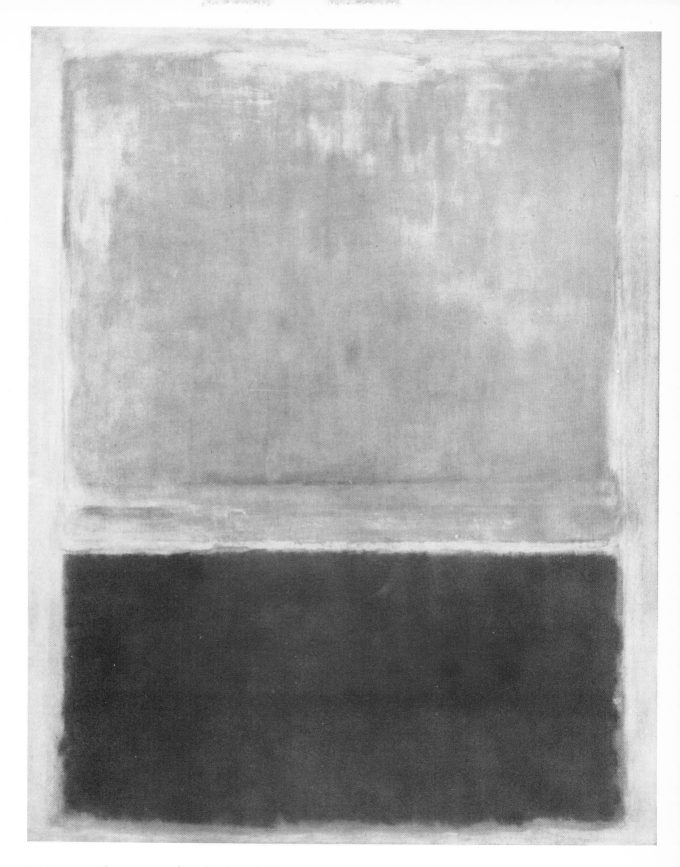

No. 8, 1953. Oil on canvas, 9′ 9¹/₂″ × 7′ 7³/₄″. Sidney Janis Gallery, New York

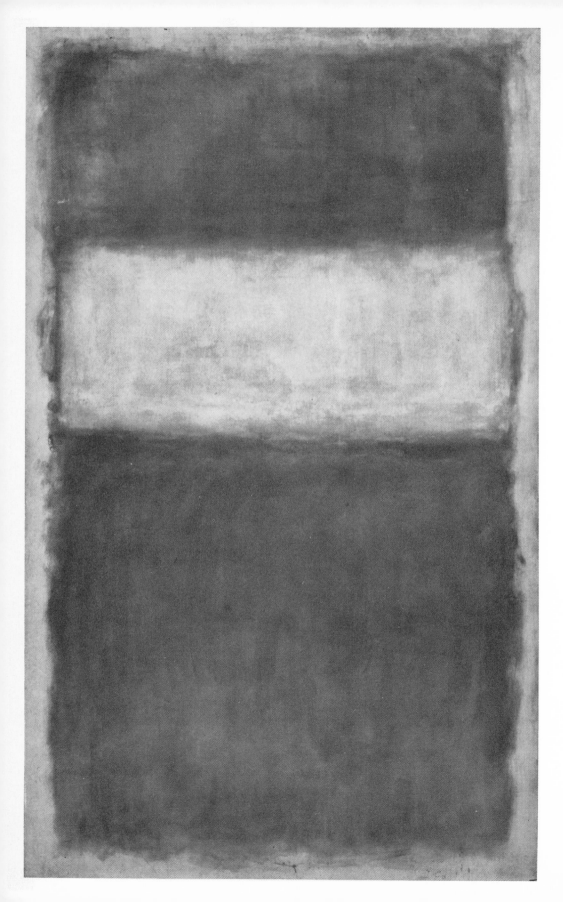

No. 2, 1954.
Oil on canvas, 9′ 5³/₄″×68¹/₂″.
Sidney Janis Gallery, New York

Opposite: *No. 18, 1952.*
Oil on canvas, 9′ 8¹/₄″×7′ 7³/₈″.
Sidney Janis Gallery, New York

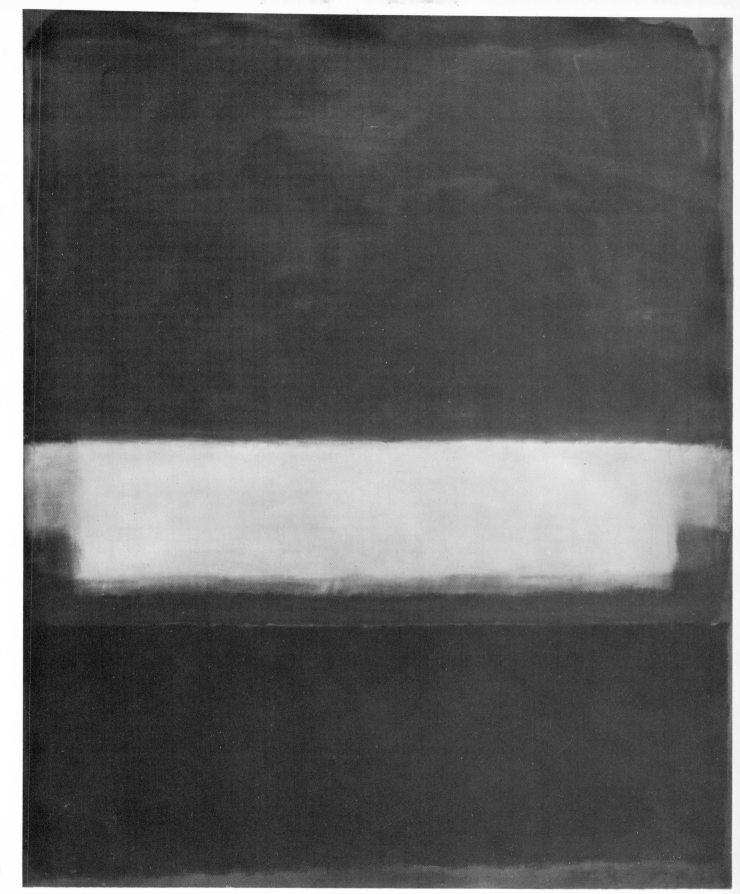

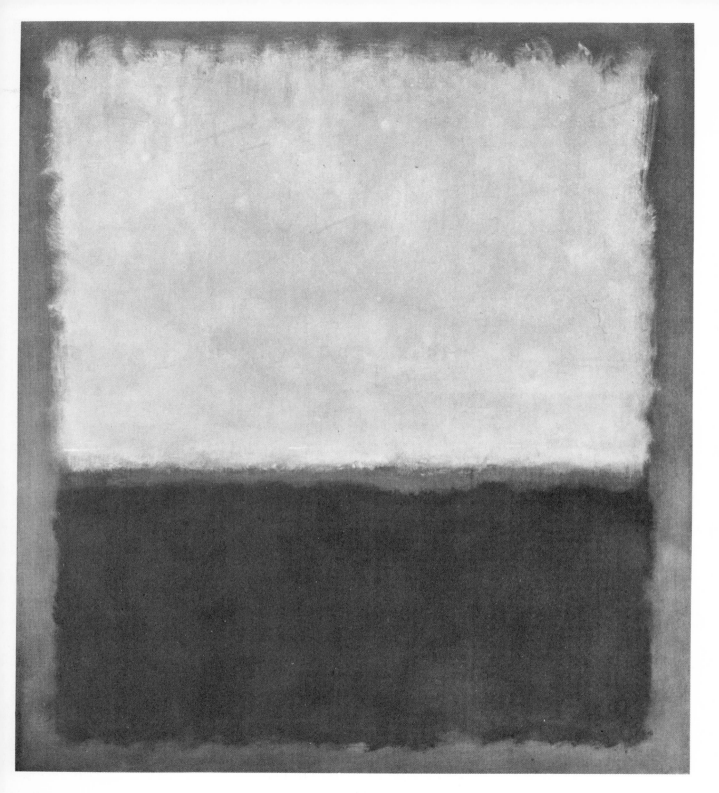

Light, Earth and Blue. 1954. Oil on canvas, 6′ 3³/₄″ × 67″. Collection Lady D'Avigdor Goldsmid, London

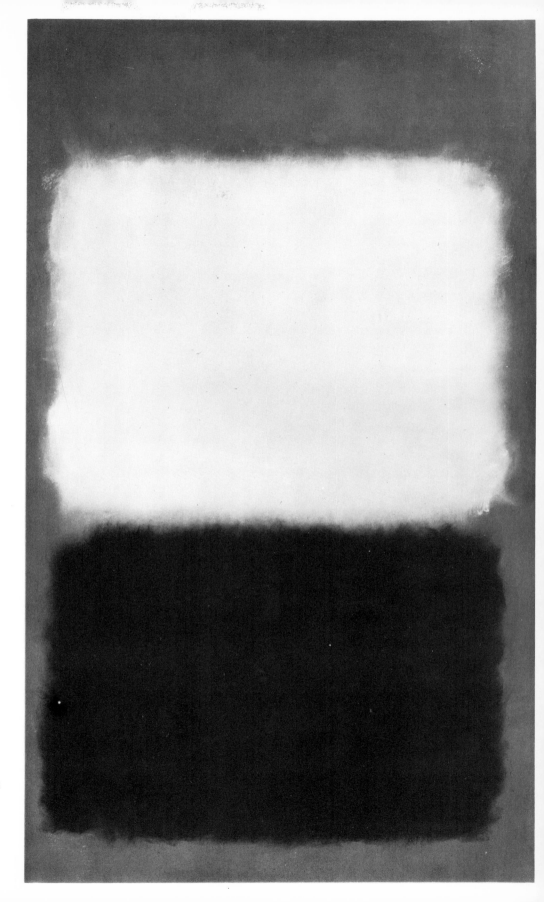

The Black and the White. 1956.
Oil on canvas, 7′ 10″ × 53³/₄″. Collection
Dr. and Mrs. Frank Stanton, New York

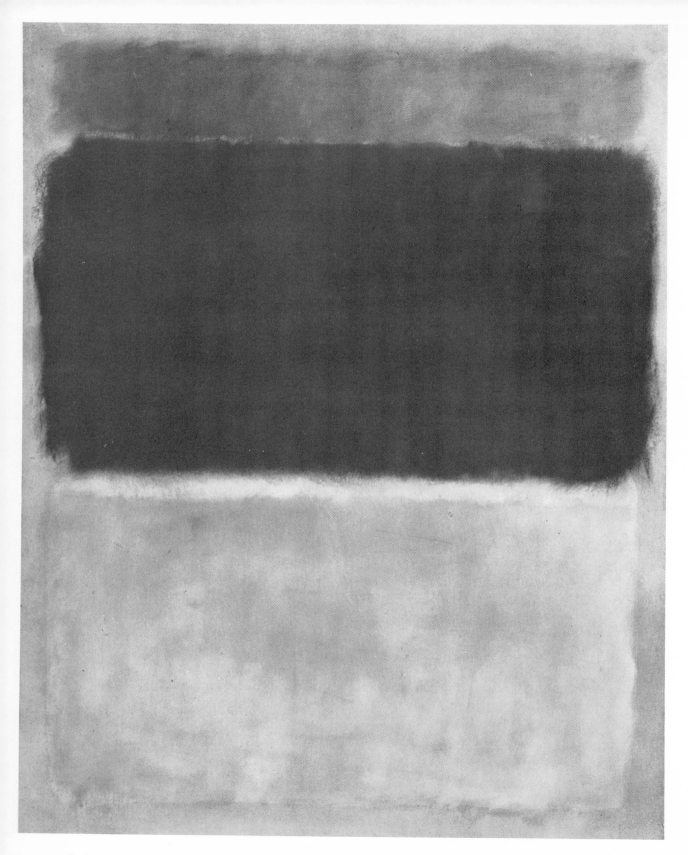

Tan and Black on Red. 1957. Oil on canvas, 69³/₈ × 53³/₈″. Collection Mr. and Mrs. I. Donald Grossman, New York

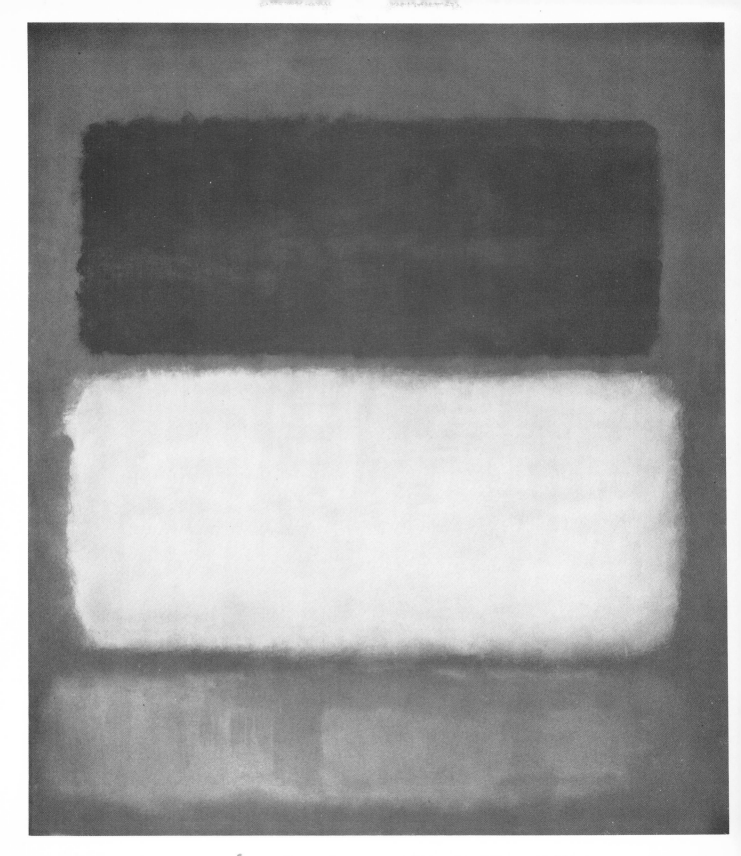

Black over Reds. 1957. Oil on canvas, 7′ 11″ × 6′ 9¹/₂″. Collection Dr. and Mrs. Edgar F. Berman, Baltimore

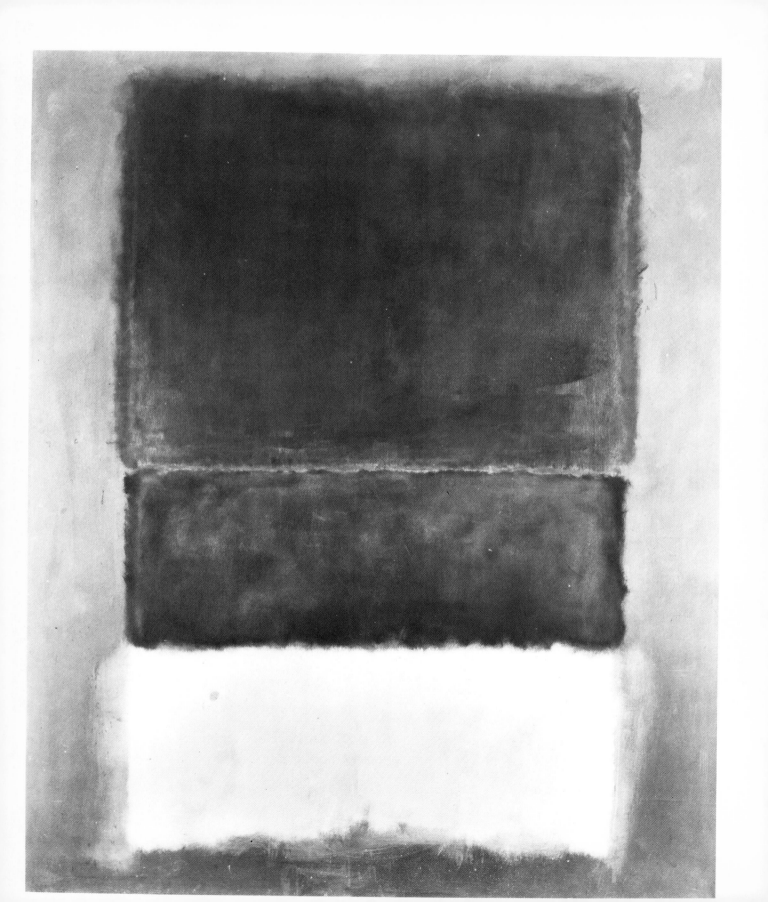

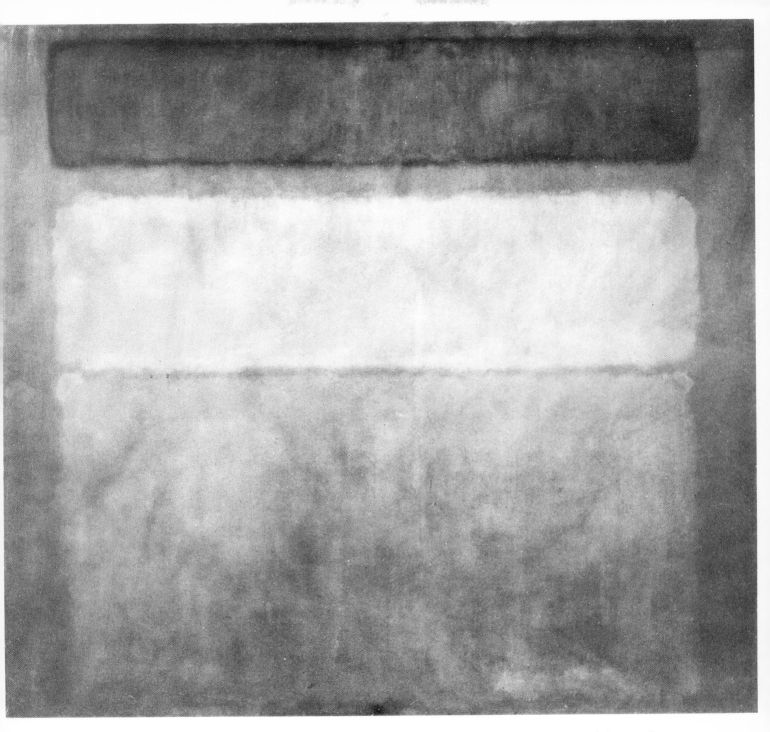

Red, Brown and Black, 1958. Oil on canvas, 8′ 10⅝″×9′ 9½″. The Museum of Modern Art, Mrs. Simon Guggenheim Fund

Opposite: *White and Greens in Blue.* 1957. Oil on canvas, 8′ 4″×6′ 10″. Collection Nelson A. Rockefeller, New York

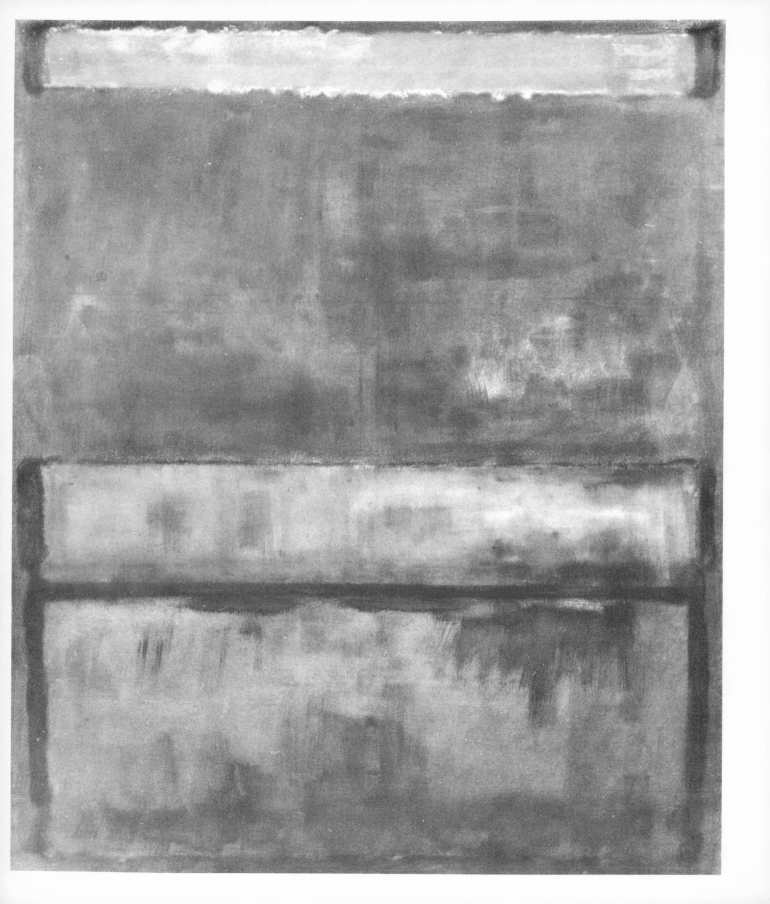

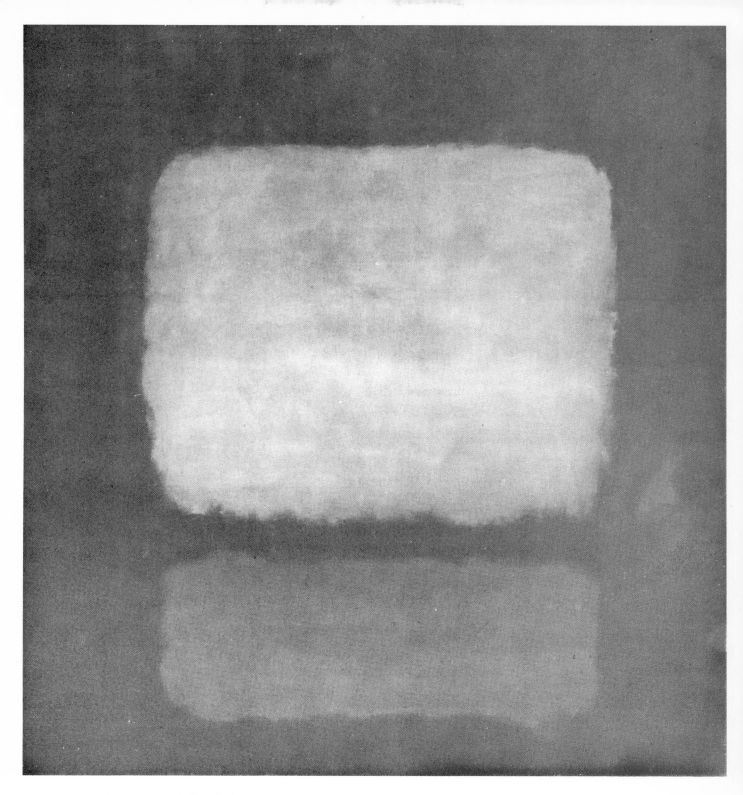

No. 19, 1958. Oil on canvas, 8′ 9″ × 7′ 6″. Sidney Janis Gallery, New York

Opposite: *No. 9, 1958*. Oil on canvas, 8′ 3″ × 6′ 10″. Collection Mr. and Mrs. Donald Blinken, New York

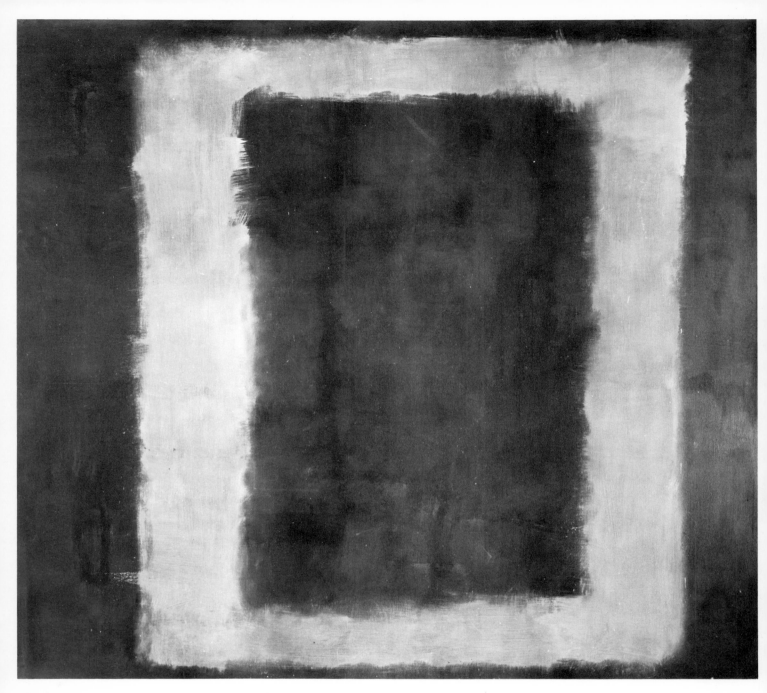

Sketch for *Mural No. 1, 1958*. Oil on canvas, 8′ 9″ × 10′. Owned by the artist

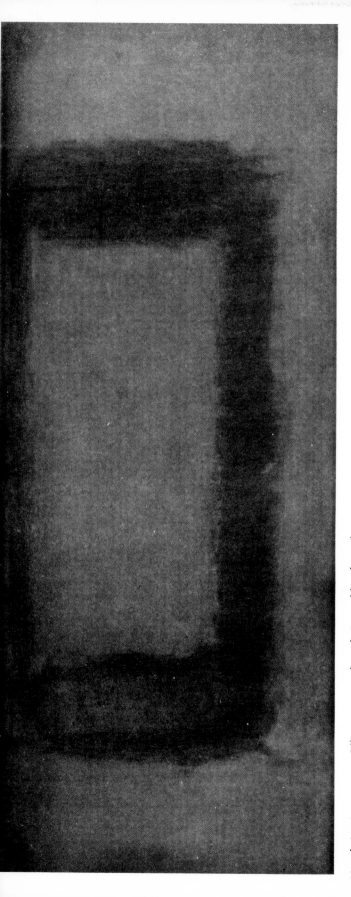

Mural, Section 7, 1959. Oil on canvas, 6′ × 15′. Owned by the artist

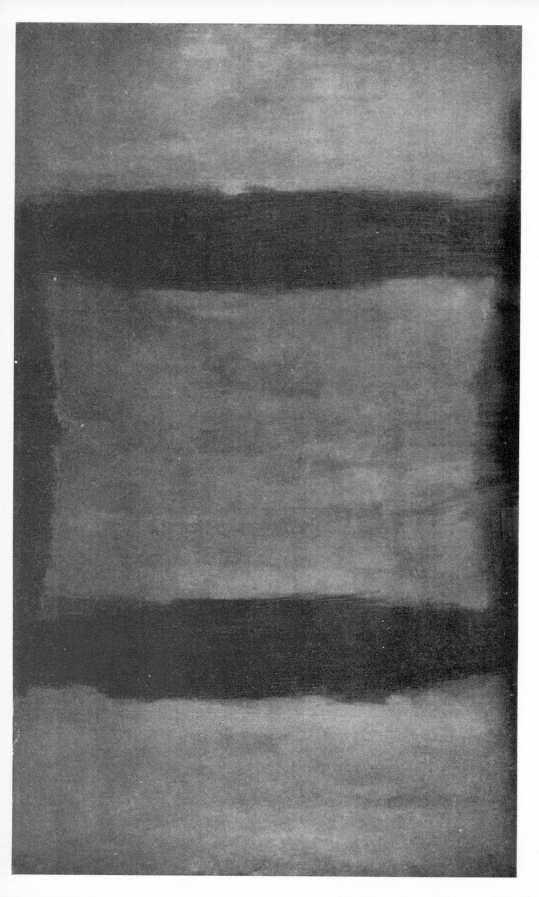

Mural, Section 3, 1959. Oil on canvas, 8′ 9″ × 15′. Owned by the artist

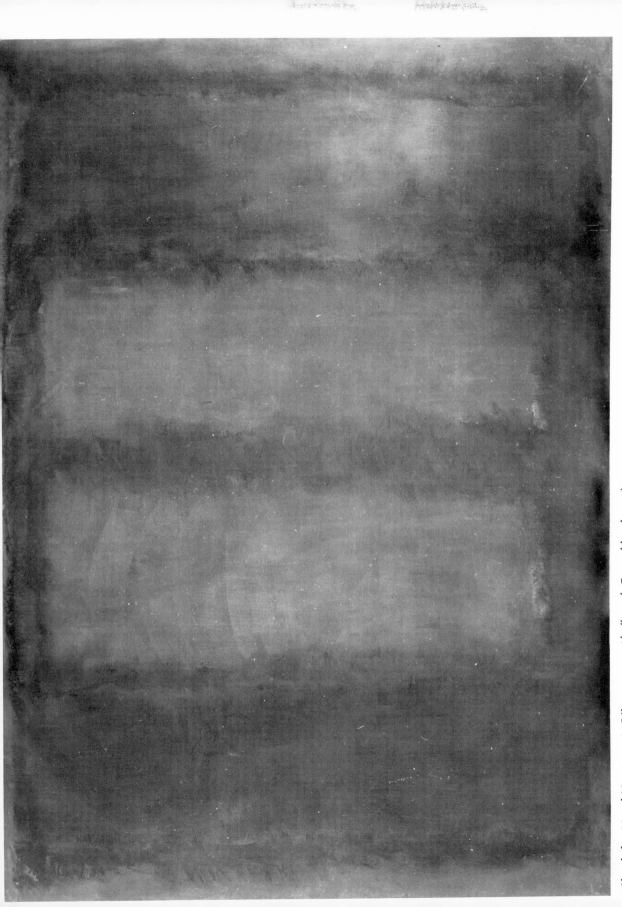

Sketch for *Mural No. 6*, *1958*. Oil on canvas, 8′ 9″ × 12′. Owned by the artist

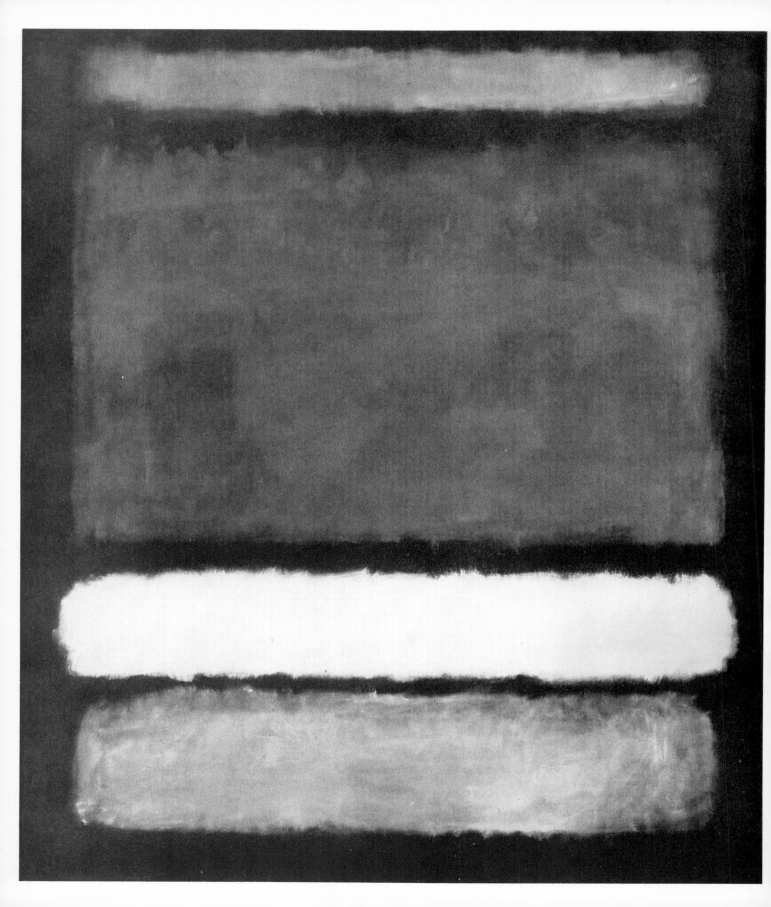

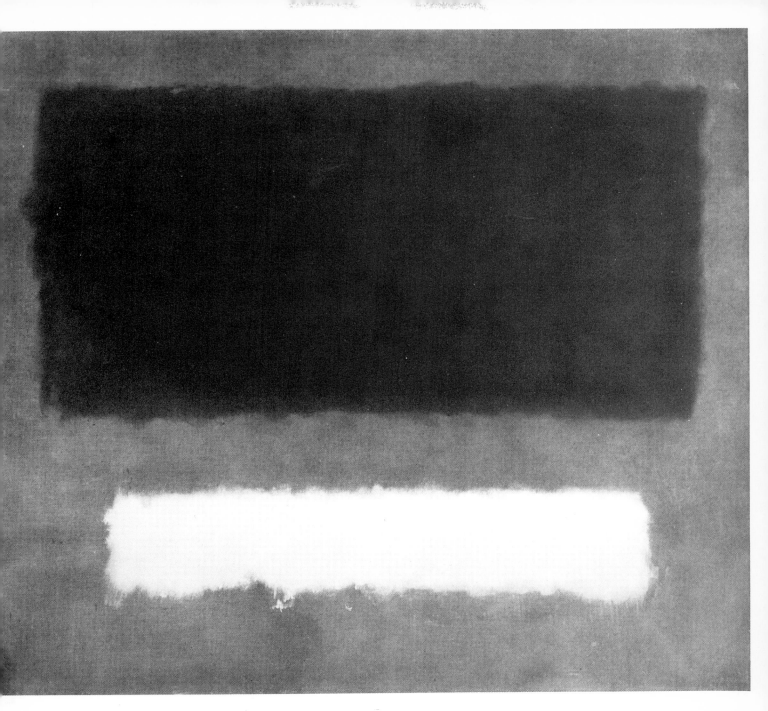

o. 8, 1960. Oil on canvas, 7′ 6″ × 8′ 6″. Sidney Janis Gallery, New York

o. 7, 1960. Oil on canvas, 8′ 9″ × 7′ 9″. Sidney Janis Gallery, New York

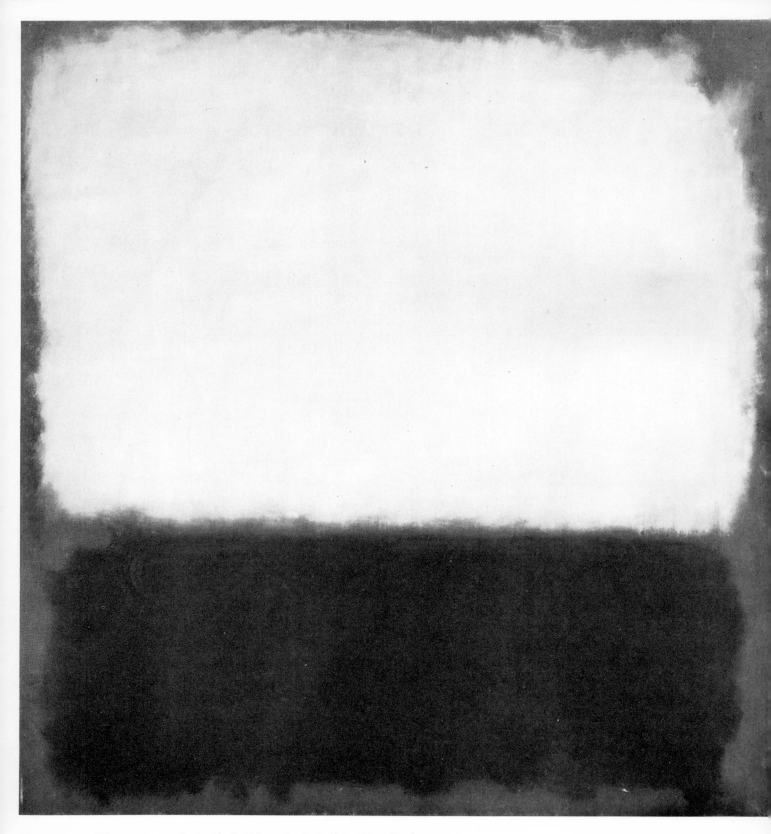

No. 14, 1960. Oil on canvas, 9' 5" × 8' 9". Sidney Janis Gallery, New York

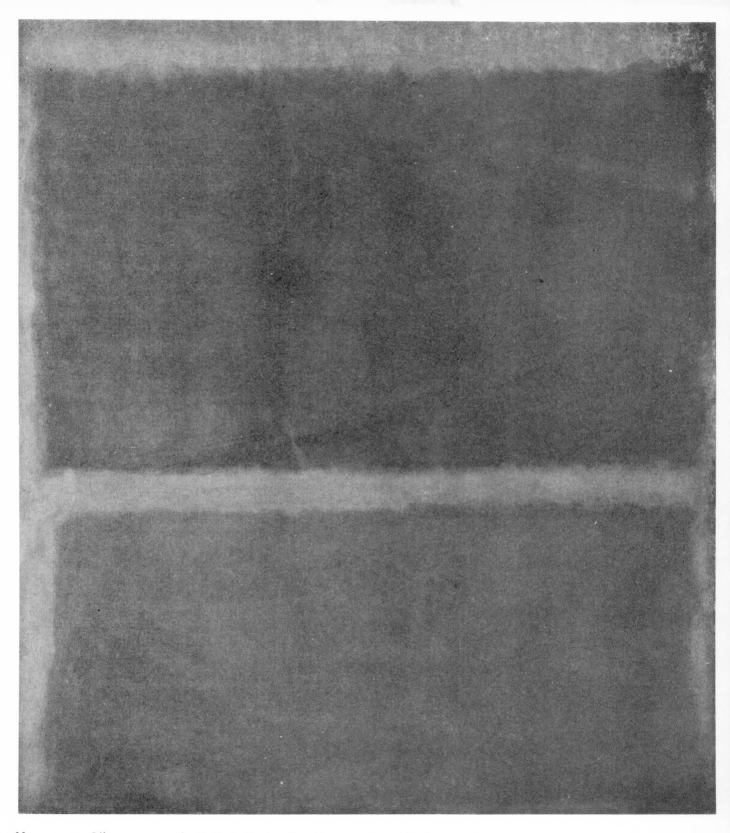

No. 12, 1960. Oil on canvas, 10′ × 8′ 9″. Collection Dr. Giuseppe Panza di Biumo, Milan

BIBLIOGRAPHY by Annaliese Munetic

BY ROTHKO

1 Letter. *New York Times* June 13, 1943. *Jointly with Adolph Gottlieb; quoted in bibl. 15 (p. 145), 9 (p. 226–7).*

2 The romantics were prompted. *Possibilities* no. 1:84 plus 7 ill. Winter 1947–48.

3 [Statement.] *Tiger's Eye* 9:109–114 ill. Oct. 1949. *On occasion of Parsons exhibition; quoted frequently. Additional brief text, 2:44 Dec. 1947.*

4 [Quotation] in: A symposium on how to combine architecture, painting and sculpture. *Interiors* 110:104 May 1951. *Includes artist's statement from the floor, Museum of Modern Art auditorium, March 19, 1951.*

ABOUT ROTHKO

5 ASHTON, DORE. Art: Lecture by Rothko. *New York Times* p. 26, col. 2 Oct. 31, 1958. *Lecture at Pratt Institute.*

5a ASHTON, DORE. Perspective de la peinture americaine. *Cahiers d'Art* 33–35:214 ill. 1960.

6 ASHTON, DORE. Art: Mark Rothko. *Arts and architecture* 74 no. 8:8, 31 ill. Aug. 1957; 75 no. 4:8, 29, 32 Apr. 1958. *On occasion of Janis exhibition.*

7 Art Since 1945 p. 312–314 et passim ill. New York, Abrams, 1958. *Chapter by Sam Hunter.*

8 BARKER, VIRGIL. From Realism to Reality p. 89–91 ill. Lincoln, University of Nebraska, 1959.

9 BLESH, RUDI. Modern Art USA p. 264–266 et passim New York, Knopf, 1956.

10 COLLIER, OSKAR. Mark Rothko. *Iconograph* p. 40–44 ill. Fall 1947.

11 CREHAN, HUBERT. Rothko's wall of light; exhibition at the Art Institute of Chicago. *Arts Digest* 29:5, 19 ill. Nov. 1 1954.

12 DE KOONING, ELAINE. Two Americans in action: Kline and Rothko. *Art News Annual* 27 pt. 2:86–97, 174–179 ill. Nov. 1957. *1958 Annual. See bibl. 26.*

13 GOLDWATER, ROBERT. Reflections on the New York School. *Quadrum* no. 8:25 ill. 1960.

14 GREENBERG, CLEMENT. "American type" painting. *Partisan Review* 22 no. 2:179–196 Spring 1955.

15 HESS, THOMAS B. Abstract Painting: Background and American Phase p. 145–150 plus ill. New York, Viking, 1951.

HUNTER, SAM. *See bibl. 7, 28.*

16 JANIS, SIDNEY. Abstract and Surrealist Art in America p. 88, 118 New York, Reynal & Hitchcock, 1944. *Reproduction and statement by Rothko on "The Omen of the Eagle."*

17 KUH, KATHERINE. Mark Rothko: recent paintings. *The Art Institute of Chicago. Quarterly* 48 no. 4:68 Nov. 15, 1954. *On occasion of the exhibition at the Institute.*

18 MacAGY, DOUGLAS. Mark Rothko. *Magazine of Art* 42:20–21 ill. Jan. 1949.

19 Mark Rothko; luminous lines to evoke emotions and mystery. *Life* 47:82–83 ill. Nov. 16, 1959.

20 OERI, GEORGINE. Tobey and Rothko. *Baltimore Museum of Art News* 23 no. 2:2–8 ill. Winter 1960.

21 RODMAN, SELDEN. Conversations with Artists p. 92–96 et passim New York, Devin-Adair, 1957.

22 SEUPHOR, MICHEL. Dictionary of Abstract Painting p. 254–255 ill. New York, Paris Book Center, 1957.

23 URBANA. UNIVERSITY OF ILLINOIS. Contemporary American Painting p. 200, 1950; p. 214 ill. 1951.

24 VILLA, EMILIO and DRUDI, GABRIELLE. Idée de Rothko; Mark Rothko. *Appia* (Rome) no. 2: [5 p.] incl. ill. 1960. *On occasion of exhibition Rome, Galleria Nazionale de Arte Moderna, 1960.*

25 Wild ones. *Time* 67:70, 74–5 ill. Feb. 20, 1956.

SELECTED EXHIBITION CATALOGUES

26 HOUSTON. CONTEMPORARY ART MUSEUM. Mark Rothko. 1957. *Preface by E. de Kooning, later published as bibl. 12.*

27 NEW YORK. MUSEUM OF MODERN ART. 15 Americans
p. 18–20 ill. 1952. *Includes statement by the artist
from bibl. 3.*

28 NEW YORK. MUSEUM OF MODERN ART. INTERNATIONAL
PROGRAM. Lipton, Rothko, Smith, Tobey: Stati Uniti
d'America. Ill. 1958. *Shown at the 29th Biennale, Ve-
nice; Rothko text by Sam Hunter.*

29 LONDON, INSTITUTE OF CONTEMPORARY ARTS. Some
Paintings from the E. J. Power Collection. 1958. *Text
by Lawrence Alloway, quotes from bibl. 2,3; ill.*

30 NEW YORK. MUSEUM OF MODERN ART. The New Ame-
rican Painting p. 68–70, 94. 1959. *Quote from
bibl. 3; separate Spanish and German editions for cir-
culating European tour.*

LIST OF EXHIBITIONS AND REVIEWS

References to magazines indicate reviews

** indicates catalogue published*

ONE-MAN EXHIBITIONS

1933 Portland, Ore. Art Museum
New York. Contemporary Arts. Nov. 29–Dec. 9

1945 New York. Art of This Century.* Jan. 9–Feb. 4
Art News 43:27 Jan. 15; *Art Digest* 19:15 ill.
Jan. 15

1946 Santa Barbara. Museum of Art
New York. Mortimer Brandt Gallery (Betty Par-
sons' contemporary section). Apr. 22–May 4 (water-
colors)
Art Digest 20:19 May 1; *Art News* 45:55 Apr.
San Francisco. Museum of Art. Aug. 13–Sept. 8

1947 New York. Betty Parsons Gallery. Mar. 3–22
Art News 46:42 Mar.; *Art Digest* 21:18 Mar. 15

1948 New York. Betty Parsons Gallery. Mar. 8–27
Art News 47:63 Apr.

1949 New York. Betty Parsons Gallery. Mar. 28–Apr. 16
Art News 48:48 ill. Apr.; *Art Digest* 23:27 Apr. 15.
See bibl. 3

1950 New York. Betty Parsons Gallery. Jan. 3–21
Art Digest 24:17 Jan.; *Art News* 48:46 Feb.

1951 New York. Betty Parsons Gallery. Apr. 2–21
Art Digest 25:18 Apr. 15; *Art News* 50:43 May

1954 Providence. Rhode Island School of Design. Jan. 19–
Feb. 13.
Chicago. Art Institute. Oct. 18–Dec. 31. See bibl.
11 and 17.

1955 New York. Sidney Janis Gallery. Apr. 4–May 5
New Yorker 31:84 Apr. 23; *Art News* 54:54 June;
Arts Digest 29:23 ill. May; *Arts & Architecture*
72:8 ill. May

1957 Houston. Contemporary Arts Museum.* Sept. 5–
Oct. 6. See bibl. 26

1958 New York. Sidney Janis Gallery. Jan. 1–Feb. 22
Arts 32:56 Mar.; *Art News* 57:12 ill. Mar.; *Art In-
ternational* 2 no. 1:55. See bibl. 6

1960 Washington, D. C. Phillips Gallery. May 4–31

GROUP EXHIBITIONS

1940 Philadelphia. Pennsylvania Academy of Fine Arts
New York. Neumann-Willard Gallery. Jan. 1–27
Art News 38:12 Jan. 20

1945 New York. Whitney Museum of American Art.*
Annual exhibitions, 1945–50

1946 New York. Egan Gallery. 12 Works of Distinction.
May 20–June 8

1950 New York. Sidney Janis Gallery. Young Painters
in the U.S. and France. Oct. 22–Nov. 11
Art d'Aujourd'hui Ser. 2 no. 6:12 ill. June 1951
Between 1954 and 1960 participated in various Ja-
nis group shows

1951 New York. Museum of Modern Art. Abstract Paint-
ing and Sculpture in America.* Jan. 23–Mar. 25.
Subsequently, Rothko participated in a number of
Museum exhibitions, of which only the major ones
are listed
Berlin. Festwochen 1951. Amerikanische Malerei,
Werden und Gegenwart.* Sept. 20–Oct. 24

1952 New York. Museum of Modern Art. 15 Americans.*
Mar. 25–June 11. See bibl. 27
Paris. Galerie de France. American Vanguard Art
for Paris. Previously exhibited at Janis, 1951–52

1954 New York. Museum of Modern Art. 12 Modern
American Painters and Sculptors.* Apr. 1953–Mar.
1954. Shown in 6 European cities
Caracas. 10th Inter-American Conference, U.S. Rep-
resentation

1955 New York. Museum of Modern Art. Modern Art
in the U.S.* Shown in 8 European countries, 1955–56

1957 India. 3d International Contemporary Art Exhibi-
tion, U.S. Representation. Shown in 6 cities
London. Gimpel fils
Architectural Review 122:270 Oct.

1958 London. Institute of Contemporary Arts.* Mar. 13–
Apr. 19
Arts 32:22–23 May. See bibl. 29
New York. Museum of Modern Art. The New Ameri-
can Painting.* Apr. 19, 1958–Sept. 8, 1959. Shown
in 8 European countries and at the Museum
Art News 58:30–33 ill. June 1959. See bibl. 30
Venice. 29th Biennale.* See bibl. 28. Also represen-
ted in 24th Biennale, 1948

1959 Albany. Institute of History and Art. Recent Ameri-
can Painting. Sept. 25–Oct. 25. From the Collec-
tions of The Museum of Modern Art
Kassel. Documenta II.* U.S. Representation
July 11–Oct. 11
Moscow. American National Exhibition.* July 7–
Sept. 5

1960 Rome. Galleria Nazionale de Arte Moderna.
Jan. 23–Febr. 22. See bibl. 24
Columbus, O. Gallery of Fine Arts. Contemporary
American Painting.* Jan. 14–Feb. 18
Paris. Galerie Neufville. Feb. 23–Mar. 22
Milan. Galleria dell'Ariete. Undici Americani.*
Beginning Apr. 27
Minneapolis. Walker Art Center. 60 American Pain-
ters. Apr. 3–May 8
Art News 59:32–36 ill. May

 A. M.

xhibition dates January 18–March 12, 1961

*ems marked by an asterisk are illustrated. In dimen-
ons, height precedes width.*

aptismal Scene. 1945. Watercolor, 19⁷/₈ × 14″. Whitney Museum of American Art, New York. Ill. p. 15

ntitled. 1946. Watercolor, 38³/₄ × 25¹/₂″. Collection Mr. and Mrs. Donald Blinken, New York. Ill. p. 15

ncestral Imprint. 1946. Watercolor. Collection John Ciampi, New York

o. 24, 1947. Oil on canvas, 33¹/₂ × 50″. Owned by the artist. Ill. p. 16

o. 32, 1947. Oil on canvas, 29¹/₂ × 50¹/₂″. Owned by the artist

o. 5, 1948. Oil on canvas, 67 × 34″. Collection Mrs. Josephine Kantor, Pacific Palisades, California

o. 12, 1948. Oil on canvas, 58 × 64″. Phillips Collection, Washington, D.C. Ill. p. 17

o. 15, 1948. Oil on canvas, 52¹/₄ × 29¹/₂″. Owned by the artist.

o. 16, 1948. Oil on canvas, 68 × 54″. Collection Theodoros Stamos, New York

o. 18, 1948. Oil on canvas, 67¹/₄ × 56″. Vassar College, Poughkeepsie, New York. Ill. p. 18

o. 19, 1948. Oil on canvas, 68 × 40″. The Art Institute of Chicago, anonymous gift. Ill. p. 19

o. 11, 1949. Oil on canvas, 68 × 48″. Owned by the artist

o. 13, 1949. Oil on canvas, 7′ 1¹/₂″ × 64¹/₂″. Owned by the artist

o. 15, 1949. Oil on canvas, 68 × 42″. Owned by the artist

o. 20, 1949. Oil on canvas, 8′ 9¹/₄″ × 52¹/₂″. Owned by the artist

o. 21, 1949. Oil on canvas, 7′ 10″ × 53¹/₄″. Owned by the artist

o. 24, 1949. Oil on canvas, 7′ 4¹/₂″ × 57¹/₂″. Collection Miss Jeanne Reynal, New York

No. 20, 1950. Oil on canvas, 9′ 8¹/₄″ × 8′ 5³/₈″. Sidney Janis Gallery, New York

* *No. 22, 1950.* Oil on canvas, 9′ 9¹/₂″ × 8′ 10³/₄″. Sidney Janis Gallery, New York. Ill. p. 20

* *No. 8, 1952.* Oil on canvas, 6′ 8¹/₂″ × 68″. Collection Mr. and Mrs. Burton G. Tremaine, Meriden, Connecticut. Ill. p. 13

* *No. 18, 1952.* Oil on canvas, 9′ 8¹/₄″ × 7′ 7³/₈″. Sidney Janis Gallery, New York. Ill. p. 23

* *No. 8, 1953.* Oil on canvas, 9′ 9¹/₂″ × 7′ 7³/₄″. Sidney Janis Gallery, New York. Ill. p. 21

No. 10, 1953. Oil on canvas, 76¹/₂ × 67¹/₂″. Collection Mr. and Mrs. Ben Heller, New York

* *No. 2, 1954.* Oil on canvas, 9′ 5³/₄″ × 68¹/₈″. Sidney Janis Gallery, New York. Ill. p. 22

No. 27, 1954. Oil on canvas, 6′ 9″ × 7′ 3″. Collection Mr. and Mrs. Ben Heller, New York

Homage to Matisse. 1954. Oil on canvas, 8′ 9″ × 50¹/₂″. Owned by the artist

* *Light, Earth and Blue.* 1954. Oil on canvas, 6′ 3³/₄″ × 67″. Collection Lady D'Avigdor Goldsmid, London. Ill. p. 24

No. 14, 1955. Oil on canvas, 7′ 7″ × 63¹/₄″. Owned by the artist

* *The Black and the White.* 1956. Oil on canvas, 7′ 10″ × 53³/₄″. Collection Dr. and Mrs. Frank Stanton, New York. Ill. p. 25

Orange and Yellow. 1956. Oil on canvas, 7′ 7″ × 71″. Albright Art Gallery, Buffalo, New York, gift of Seymour H. Knox.

No. 3, 1956. Oil on canvas, 66 × 61″. Sidney Janis Gallery, New York

* *Tan and Black on Red.* 1957. Oil on canvas, 69⁵/₈ × 53³/₈″. Collection Mr. and Mrs. I. Donald Grossman, New York. Ill. p. 26

* *White and Greens in Blue.* 1957. Oil on canvas, 8′ 4″ × 6′ 10″. Nelson A. Rockefeller, New York. Ill. p. 28

* *Black over Reds.* 1957. Oil on canvas, 7′ 11″ × 6′ 9¹/₂″. Dr. and Mrs. Edgar F. Berman, Baltimore. Ill. p. 27

No. 16, 1957. Oil on canvas, 8′ 8¹/₂″ × 9′ 6¹/₂″. Sidney Janis Gallery, New York

No. 47, 1957. Oil on paper, 27³/₄×24³/₄″. Collection Mr. and Mrs. Bernard J. Reis, New York

* *Red, Brown and Black*. 1958. Oil on canvas, 8′ 10⁵/₈″×9′ 9¹/₂″. The Museum of Modern Art, Mrs. Simon Guggenheim Fund. Ill. p. 29

* *No. 9, 1958*. Oil on canvas, 8′ 3″×6′ 10″. Collection Mr. and Mrs. Donald Blinken, New York. Ill. p. 30

White and Black on Wine. 1958. Oil on canvas, 8′ 9″×14′. Collection Mr. and Mrs. William Rubin, New York

* *No. 19, 1958*. Oil on canvas, 8′ 9″×7′ 6″. Sidney Janis Gallery, New York, Ill. p. 31

* Sketch for *Mural No. 1, 1958*. Oil on canvas, 8′ 9″×10′. Owned by the artist. Ill. p. 32

Sketch for *Mural No. 4, 1958*. Oil on canvas, 8′ 9″×12′. Owned by the artist.

* Sketch for *Mural No. 6, 1958*. Oil on canvas, 8′ 9″×12′. Owned by the artist. Ill. p. 35

Sketch for *Mural No. 7, 1958–59*. Oil on canvas, 8′ 9″×14′. Owned by the artist

Mural, Section 2, 1959. Oil on canvas, 8′ 9″×15′. Owned by the artist

* *Mural, Section 3, 1959*. Oil on canvas, 8′ 9″×15′. Owned by the artist. Ill. p. 34

Mural, Section 4, 1959. Oil on canvas, 8′ 9″×7′ 10″. Owned by the artist.

Mural, Section 5, 1959. Oil on canvas, 6′×15′. Owned by the artist.

* *Mural, Section 7, 1959*. Oil on canvas, 6′×15′. Owned by the artist. Ill. p. 33

Mural for End Wall. 1959. Oil on canvas, 8′ 9″×9′ 5″. Owned by the artist.

* *No. 7, 1960*. Oil on canvas, 8′ 9″×7′ 9″. Sidney Janis Gallery, New York. Ill. p. 36

* *No. 8, 1960*. Oil on canvas, 7′ 6″×8′ 6″. Sidney Janis Gallery, New York. Ill. p. 37

* *No. 12, 1960*. Oil on canvas, 10′×8′ 9″. Collection Dr. Giuseppe Panza di Biumo, Milan. Ill. p. 39

* *No. 14, 1960*. Oil on canvas, 9′ 5″×8′ 9″. Sidney Janis Gallery, New York. Ill. p. 38

Museum of Modern Art Publications in Reprint

Abstract Painting and Sculpture in America. 1951. Andrew Carnduff Ritchie

African Negro Art. 1935. James Johnson Sweeney

American Art of the 20's and 30's: Paintings by Nineteen Living Americans; Painting and Sculpture by Living Americans; Murals by American Painters and Photographers. 1929. Barr; Kirstein and Levy

American Folk Art: The Art of the·Common Man in America, 1750-1900. 1932. Holger Cahill

American Painting and Sculpture: 1862-1932. 1932. Holger Cahill

American Realists and Magic Realists. 1943. Miller and Barr; Kirstein

American Sources of Modern Art. 1933. Holger Cahill

Americans 1942-1963; Six Group Exhibitions. 1942-1963. Dorothy C. Miller

Ancient Art of the Andes. 1954. Bennett and d'Harnoncourt

The Architecture of Bridges. 1949. Elizabeth B. Mock

The Architecture of Japan. 1955. Arthur Drexler

Art in Our Time; 10th Anniversary Exhibition. 1939.

Art Nouveau; Art and Design at the Turn of the Century. 1959. Selz and Constantine

Arts of the South Seas. 1946. Linton, Wingert, and d'Harnoncourt

Bauhaus: 1919-1928. 1938. Bayer, W. Gropius and I. Gropius

Britain at War. 1941. Eliot, Read, Carter and Dyer

Built in U.S.A.: 1932-1944; Post-War Architecture. 1944. Mock; Hitchcock and Drexler

Cézanne, Gauguin, Seurat, Van Gogh: First Loan Exhibition. 1929. Alfred H. Barr, Jr.

Marc Chagall. 1946. James Johnson Sweeney

Giorgio de Chirico. 1955. James Thrall Soby

Contemporary Painters. 1948. James Thrall Soby

Cubism and Abstract Art. 1936. Alfred H. Barr, Jr.

Salvador Dali. 1946. James Thrall Soby

James Ensor. 1951. Libby Tannenbaum

Max Ernst. 1961. William S. Lieberman

Fantastic Art, Dada, Surrealism. 1947. Barr; Hugnet

Feininger-Hartley. 1944. Schardt, Barr, and Wheeler

The Film Index: A Bibliography (Vol. 1, The Film as Art). 1941.

Five American Sculptors: Alexander Calder; The Sculpture of John B. Flannagan; Gaston Lachaise; The Sculpture of Elie Nadelman; The Sculpture of Jacques Lipchitz. 1935-1954. Sweeney; Miller, Zigrosser; Kirstein; Hope

Five European Sculptors: Naum Gabo—Antoine Pevsner; Wilhelm Lehmbruck—Aristide Maillol; Henry Moore. 1930-1948. Read, Olson, Chanin; Abbott; Sweeney

Four American Painters: George Caleb Bingham; Winslow Homer, Albert P. Ryder, Thomas Eakins. 1930-1935. Rogers, Musick, Pope; Mather, Burroughs, Goodrich

German Art of the Twentieth Century. 1957. Haftmann, Hentzen and Lieberman; Ritchie

Vincent van Gogh: A Monograph; A Bibliography. 1935, 1942. Barr; Brooks

Arshile Gorky. 1962. William C. Seitz

Hans Hofmann. 1963. William C. Seitz

Indian Art of the United States. 1941. Douglas and d'Harnoncourt

Introductions to Modern Design: What is Modern Design?; What is Modern Interior Design? 1950-1953. Edgar Kaufmann, Jr.

Paul Klee: Three Exhibitions: 1930; 1941; 1949. 1945-1949. Barr; J. Feininger, L. Feininger, Sweeney, Miller; Soby

Latin American Architecture Since 1945. 1955. Henry-Russell Hitchcock

Lautrec-Redon. 1931. Jere Abbott

Machine Art. 1934. Philip Johnson

John Marin. 1936. McBride, Hartley and Benson

Masters of Popular Painting. 1938. Cahill, Gauthier, Miller, Cassou, et al.

Matisse: His Art and His Public. 1951. Alfred H. Barr, Jr.

Joan Miró. 1941. James Johnson Sweeney

Modern Architecture in England. 1937. Hitchcock and Bauer

Modern Architecture: International Exhibition. 1932. Hitchcock, Johnson, Mumford; Barr

Modern German Painting and Sculpture. 1931. Alfred H. Barr, Jr.

Modigliani: Paintings, Drawings, Sculpture. 1951. James Thrall Soby

Claude Monet: Seasons and Moments. 1960. William C. Seitz

Edvard Munch; A Selection of His Prints From American Collections. 1957. William S. Lieberman

The New American Painting; As Shown in Eight European Countries, 1958-1959. 1959. Alfred H. Barr, Jr.

New Horizons in American Art. 1936. Holger Cahill

New Images of Man. 1959. Selz; Tillich

Organic Design in Home Furnishings. 1941. Eliot F. Noyes

Picasso: Fifty Years of His Art. 1946. Alfred H. Barr, Jr.

Prehistoric Rock Pictures in Europe and Africa. 1937. Frobenius and Fox

Diego Rivera. 1931. Frances Flynn Paine

Romantic Painting in America. 1943. Soby and Miller

Medardo Rosso. 1963. Margaret Scolari Barr

Mark Rothko. 1961. Peter Selz

Georges Roualt: Paintings and Prints. 1947. James Thrall Soby

Henri Rousseau. 1946. Daniel Catton Rich

Sculpture of the Twentieth Century. 1952. Andrew Carnduff Ritchie

Soutine. 1950. Monroe Wheeler

Yves Tanguy. 1955. James Thrall Soby

Tchelitchew: Paintings, Drawings. 1942. James Thrall Soby

Textiles and Ornaments of India. 1956. Jayakar and Irwin; Wheeler

Three American Modernist Painters: Max Weber; Maurice Sterne; Stuart Davis. 1930-1945. Barr; Kallen; Sweeney

Three American Romantic Painters: Charles Burchfield: Early Watercolors; Florine Stettheimer; Franklin C. Watkins. 1930-1950. Barr; McBride; Ritchie

Three Painters of America: Charles Demuth; Charles Sheeler; Edward Hopper. 1933-1950. Ritchie; Williams; Barr and Burchfield

Twentieth-Century Italian Art. 1949. Soby and Barr

Twenty Centuries of Mexican Art. 1940

Edouard Vuillard. 1954. Andrew Carnduff Ritchie

The Bulletin of the Museum of Modern Art, 1933-1963. (7 vols.)